2

A student
my head always down
of the grass I mow
I missed the cranes.

"These crayons fly
in a circle ahead"
said a tall fellow.

-Lorine Niedecker

Tribute to theme

A violinist
my wrist always cocked
of passage under power
line sets
I missed the bridges.

Stay in the Loud Lane
and Don't list lateral.
I said literal.

Both teachers,
the villain
making me SAW Vivaldi
and the craning
virtuoso Boaz
called it that

2

La Creme (of all)
Bernell (estranged grandpa's
glory doorknob)
Stallion (do name a horse that,
as a practice)
(as a gilding. Of course)
Still on-form! Even standing
a richer, richer, richer
smell in a small space.

 Stall,

 try.

 Run
 time
Or muck it

A cold little July!
No derobing. --Bare
beach only up to your
ankles, thank you.

I read "Wine-red sea" in a buzzfeed
article about Homer using red
to describe sea blue.

Wine-red sea under 2014 blood moon
around the turn of midnight.

2015 moon is an Orange
Crush canned

 dusk at
 Edgewater lake

Being a circle, I mean easy
on the eye evenly gifting
 itself the broadly diffused
 cue
of the muffled sun behind our backs
Whatever one word it says
"Crush" has a brilliant
 glare

That the bed will
grow
 into the sheets

 "Fit like a King!"

 Furl highly-
 threaded--- masts,

 female condom

 JUST SHOW
 unwraps

You know

 I'll
 always salute

 you when your
 birthday comes---

6

Darling Green,
Man's Name

Queen-eyed
Pharaoh! My
Main Toss---

Darling Green
Queen-Eyed Pharoah
Main Main

Tess.

Blue Holland willow plate
Steam enerve tip tip
Broccoli, amend
 amend, fiddlehead ferns
 hype green, less, intact.

Ten pedestrians
losing their compass
in the grass north

The grass park
East quarter
 Which the water
 should be---! Past
one climbed tree
and three not
built that way---
 Flatter its leaves
 to leaf under one-
 inch wave of
 Edgewater lake

One wears
 reflective clothing
 in the presage dark
Some one walks
 a black dog
 And one
 with three dogs
 3 breeds/
 ages/
 sized fish that
 eat each other

Figs grew in mom's house
In my house the figs fell off
Tropical parkway mantle-
ing Taiga July
Well, you were---
"duped by the expert"
By virtue of (oh, almost)
lyric alone

Which lawns
cropped for exits, south?
No sense for the compass
so
 ANY

I like grass
and Sassafrass
ANY

Is it right with
me or wrong with July
---that no bites?
Less empathetic, less
flowing is my blood.
In my calves---
Reversal pools it's re-
newing itself.

"Beamed!"

down

WANTING IT

I'm open!

open

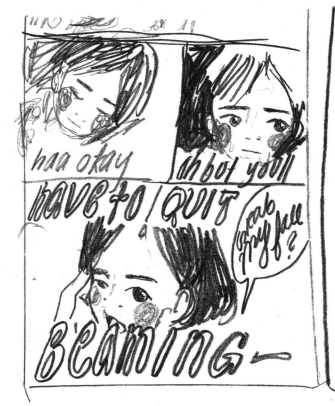

DID YOU
LIKE IT

WHAT DID YOU
HAVE before to

make you
like this?

WHAT I'VE DONE
FOR YOU NO YOU
SAID WE COULD JUST
SLEEP I DON'T KNOW
WHAT YOU WANT

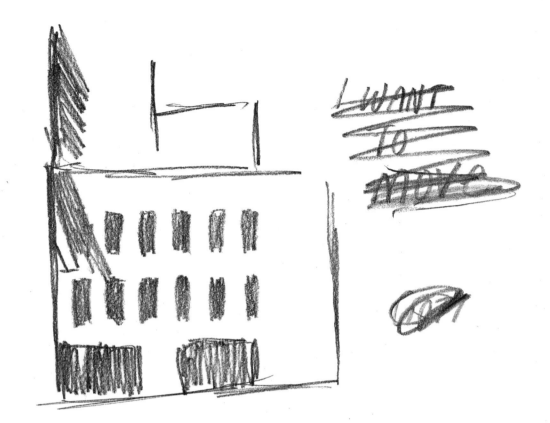

I WANT TO MOVE

DO YOU
LIKE IT HERE

get out

RESt

DID YOU HAVE A GOOD TIME

YOU WON'T

WILL YOU SAY
BYE AT LEAST

Because
Because I know
YOU'RE GOING

YOU'RE
TRYING TO
LEAVE THATS WHAT

WAN
WANTED that

wanted this

Through

You asked, YOU

wanted t

DOWN THE STEPS

~~It hurts~~

It hurt you to say

BYE TODAY

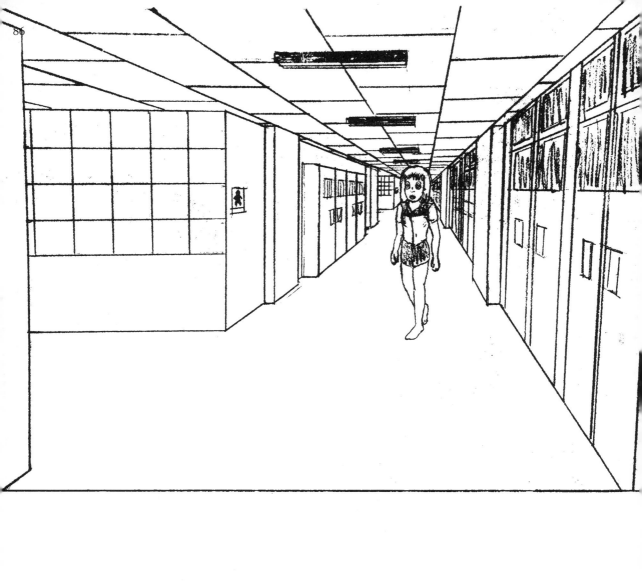

I was reading about your dad's commune

in ARCITECTÙR a

magazine...

So,

So, So...,

Is it true?

Level 2
Character
armour

Our identities have no bodies so, unlike you, we cannot obtain order by physical coercion

DORMANT/ DESUURR

it's drenched!

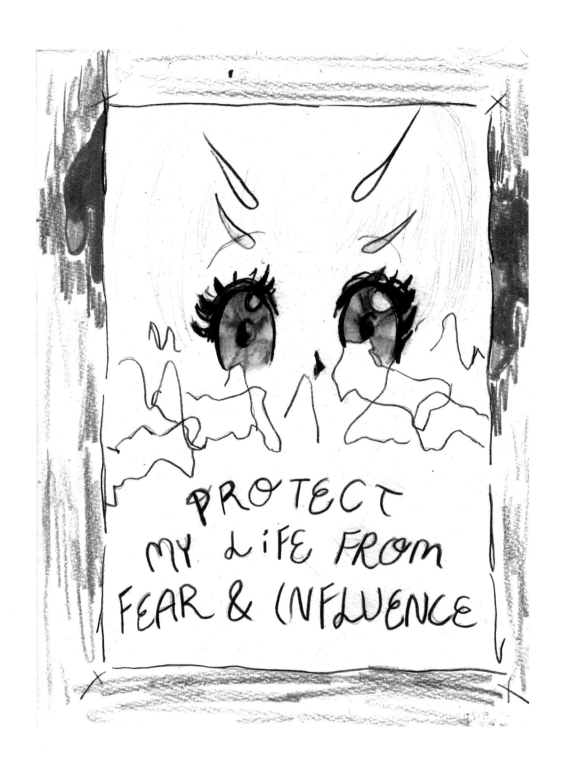

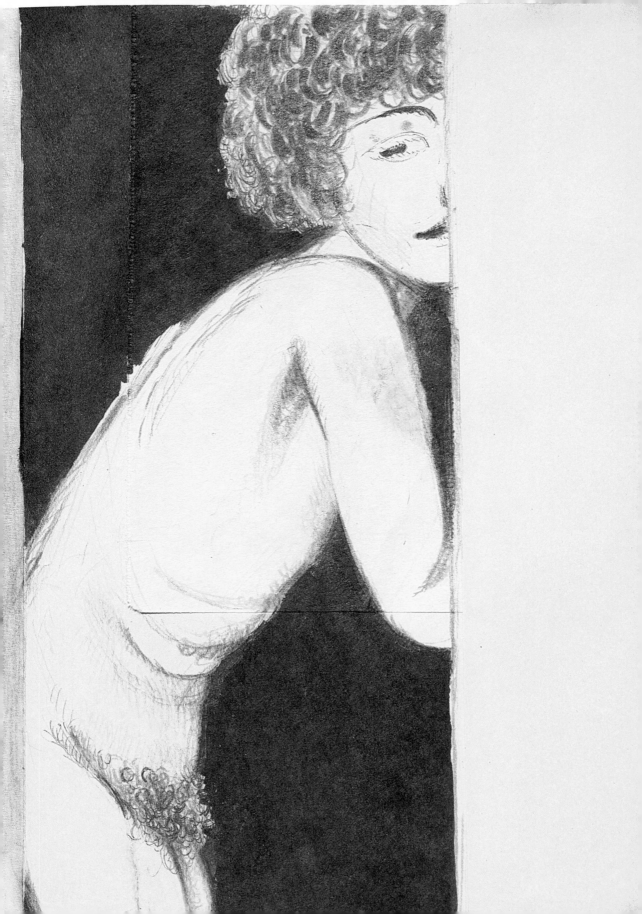

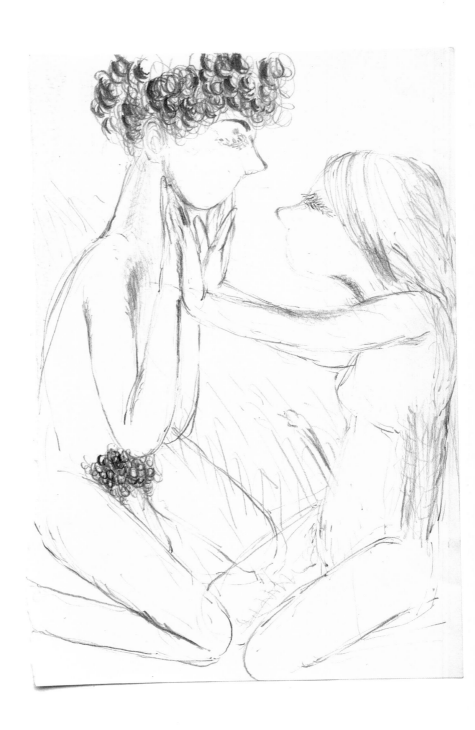

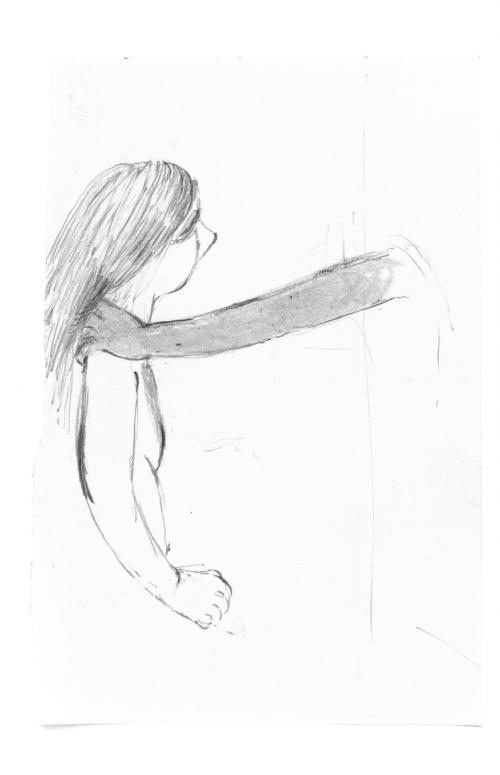

25 13

1 23 13

an annow amends———
when its gest jenkedknee ends

puddle

shadow

anchor

atten.

Tip

Tip

resolve

openface

Tip

openface 2 in 1

Tip

2 in 1 openface

p

i

p'

4-fingr / open 7
openings of the face

I remember the bed's
In the stored cage!!
terrier's photo the
gaze/
Brushed my
dime-sized
cheeks...

the body

project
tracing difference
the subjective force
view of sight
anticipation of image
fount of desire
"emission theory"
i'm hungry
to seem to travel
present projection
i was feeling kind of lazy
sight is memory
basis for relationship
imaginary space
anticipation of image v input of light
orbital significance
point of geographical origin
dmv
narcissistic optical mechanics
orient weight
reflected redundant
aspirational quota
conscious surface
dated
attachment field
completion myth
occupation
opted

the place

location of desire
surface leak
culmination of focus
hanging out with my tormentors later
screen of projection
situation anxiety
wetted
field of infinity
implicated time
plan of movement
reference the preceedings
spacial potential
pull of objects
collective memory
utopia already
historical residue
where are you living
throng of surface
surface disturbing space
"to strain through"
light complex
airmiles
relative space
situation of cause
build up
virtual composure
discipline to test
a life juxtaposed
place for making bread

NETFLIX

the oblique

deconstruction of allegory
system of doing
the screen and the frame
progress may
a side
politics
simplification of orientation
distance priority
facade the facade
subjective categorization
i get it
immobile relationship
preparation & debriefing
desire in web
subject orients the vision
the stacking of eyes along a horizon
ikea instructions
height is loss
passing
hierarchical scale
dominating concept of size
private readership
privacy
of two points
face of desire
past and future tense
deeply embarrassed
positive reinforcement
work student
an account

the vanishing point

location of absence
infinity is a unit of one
where desire moves
exit strategy
non communal
exclusionary experience
individual focus
what's left
quality of military technology
trickle down
manufactured lens
fan fiction
recommended self-actualization
drag
object narcissism
orient a foil
selective learning
opportunity myth
exit dominance
specialization of distance
theme of battle
looking with one eye
signal
hollow field
space bias
binary language
aptitude test
criticism

the ground

orientation principle
approximation
distribute
lack of display
where is the mortuary
delineation map
equal distribution of space
god is present
call to microcosmic fervour
categorical perspective
finding find found
time lapse
geographical practice
vast active
"relational aesthetics"
matter of proximity
exploitable boundaries
draw a line through time by ignoring it
brother eye
logistics of intrusion
burden of gravity
scrutiny without interest
individuality as a matter of focus
distance and isolation
macrofilm
managing calamity
pull-out
object distance
aeroplan card
you have a linear path, and you add a third point
binary extraction
abstraction of depth (information)
close or far

the fog

position of nothing
want not
breach of filigree
pregnancy
lights mass
transitory method for space
sequentially dismissive distance
symbolic absence v real absence
deconstructed landscape
i don't have a favourite movie
presence of infinity
all-d projection screen
tuesday or any day
orientation static
time difference
condensation
memory loss
singularity of sequence
non-conditional
forget about that drama
aborted escapism
cost dissolve
sleep paralysis
despecialization of distance
bad credentials
searching for proverbs online
trivial mass
favourite dog quotes

the frame

deliberation of fantasy
the condition of example
exclusion of desire
isolation
perimeter of fault
breach of habit
the desire, still excluded
fundamentalism
have a seat
intersection of experience
to slice thin
field of reason
objective preference
vertigo
industrial testimony
reverse projection
an obelisk in the marsh
360
distance leverage
an accountable fetish
incarceration rates
memorial for the dead and lost
collapse anxiety
boredom denial method
anniversary
filigree as an obvious word
closure myth
ageism
x
|

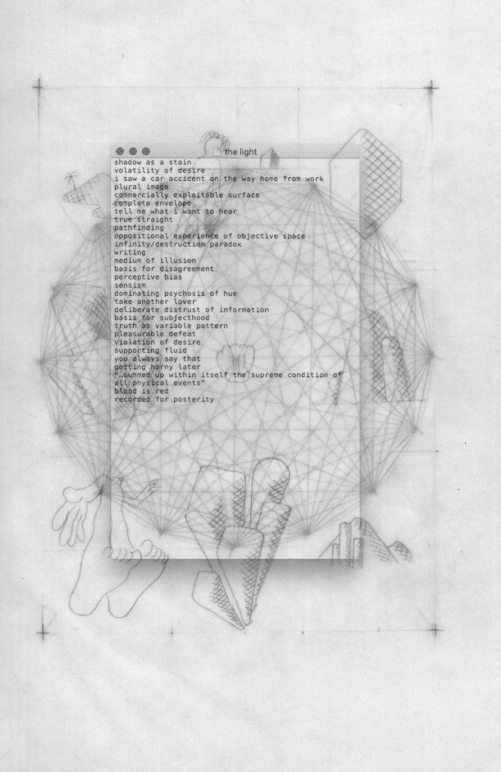

the light

shadow as a stain
volatility of desire
i saw a car accident on the way home from work
plural image
commercially exploitable surface
complete envelope
tell me what i want to hear
true straight
pathfinding
oppositional experience of objective space
infinity/destruction paradox
writing
medium of illusion
basis for disagreement
perceptive bias
sensism
dominating psychosis of hue
take another lover
deliberate distrust of information
basis for subjecthood
truth as variable pattern
pleasurable defeat
violation of desire
supporting fluid
you always say that
getting horny later
"…summed up within itself the supreme condition of
all physical events"
blood is red
recorded for posterity

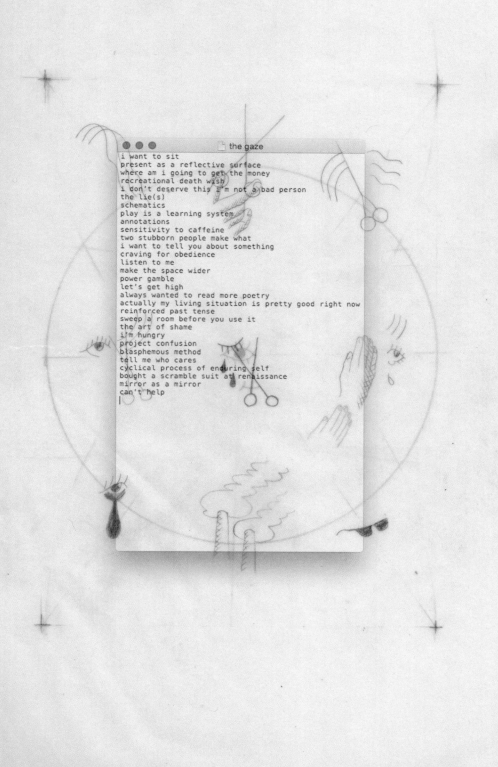

the gaze

i want to sit
present as a reflective surface
where am i going to get the money
recreational death wish
i don't deserve this i'm not a bad person
the lie(s)
schematics
play is a learning system
annotations
sensitivity to caffeine
two stubborn people make what
i want to tell you about something
craving for obedience
listen to me
make the space wider
power gamble
let's get high
always wanted to read more poetry
actually my living situation is pretty good right now
reinforced past tense
sweep a room before you use it
the art of shame
i'm hungry
project confusion
blasphemous method
tell me who cares
cyclical process of enduring self
bought a scramble suit at renaissance
mirror as a mirror
can't help

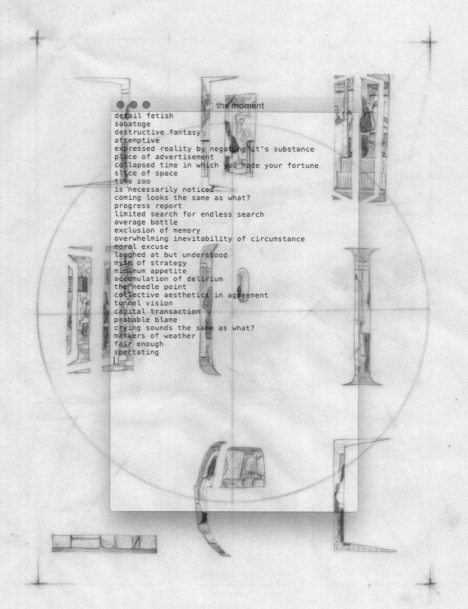

the moment

detail fetish
sabatoge
destructive fantasy
attemptive
expressed reality by negating it's substance
place of advertisement
collapsed time in which you made your fortune
slice of space
time zoo
is necessarily noticed
coming looks the same as what?
progress report
limited search for endless search
average bottle
exclusion of memory
overwhelming inevitability of circumstance
moral excuse
laughed at but understood
myth of strategy
minimum appetite
accumulation of delirium
the needle point
collective aesthetics in agreement
tunnel vision
capital transaction
probable blame
crying sounds the same as what?
markers of weather
fair enough
spectating

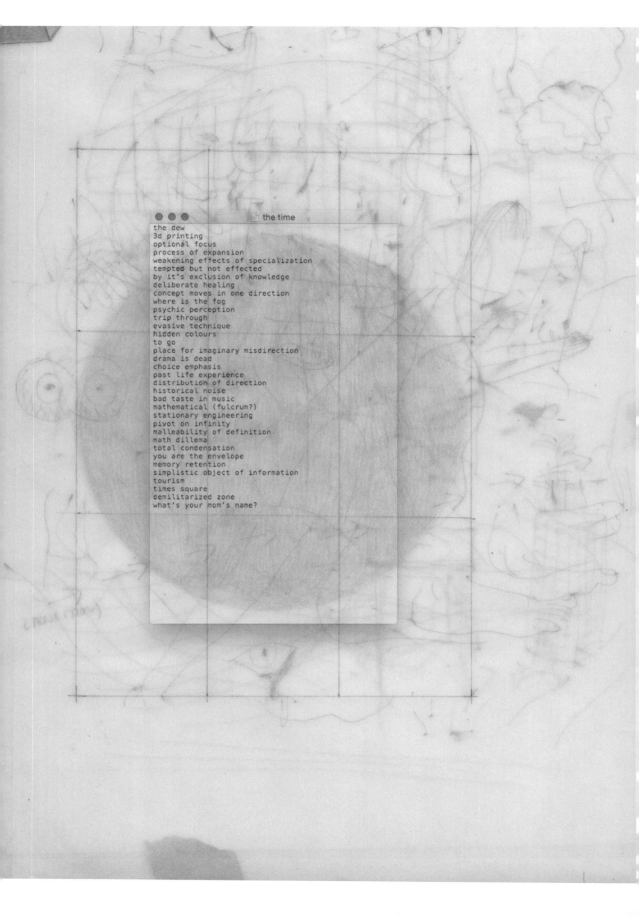

● ● ● ⬚ the time

```
the dew
3d printing
optional focus
process of expansion
weakening effects of specialization
tempted but not effected
by it's exclusion of knowledge
deliberate healing
concept moves in one direction
where is the fog
psychic perception
trip through
evasive technique
hidden colours
to go
place for imaginary misdirection
drama is dead
choice emphasis
past life experience
distribution of direction
historical noise
bad taste in music
mathematical (fulcrum?)
stationary engineering
pivot on infinity
malleability of definition
math dillema
total condensation
you are the envelope
memory retention
simplistic object of information
tourism
times square
demilitarized zone
what's your mom's name?
```

James Tiptree, Jr. writes: "[I want to] storm naked with hard-on waving thru the world spouting whatever comes." Alice (Alli) Sheldon writes: "[I want to] storm naked with hard-on waving thru the world spouting whatever comes." What is the ontological or essential status of the hard-on?

I imagine someone saying: "The injured body requires a prosthesis." Grosz writes that Darwin recognized that all bodies are prosthetic.

Could we consider the ontological or essential nature of the pseudonym? Alice (Alli) Sheldon writes under the pseudonym James Tiptree, Jr., and Katharine Burdekin writes under the pseudonym Murray Constantine. By contrast, the avatar J.T. Leroy is created by Laura Albert.

Grosz distinguishes between concepts of the function of the prosthesis as being (in Freud) to extend already existing capacities of the body, versus (in Bergson, and, via Bergson, in Deleuze) to generate new capacities and virtualities in the body.

Could we consider a third possibility, that of the prosthetic object whose function is to reduce or eliminate existing capacities of the body? Not a malfunctioning, useless prosthesis, but a prosthesis with a negative utility? Is the pseudonym a negative prosthesis?

We distinguish between the avatar and the pseudonym. The memoirs written by Laura Albert detail the fabricated life history of the projected avatar J.T. Leroy. By contrast, the life of Alli Sheldon, writing in letters as James Tiptree, Jr., was not fabricated. The avatar takes on a projected life. The pseudonym retains its prosthetic essence of attachment or encrustation.

All that Katherine Burdekin or Alli Sheldon needs to become Murray Constantine or James Tiptree, Jr. is to negate her femaleness. When Tiptree, Jr. writes in letters about his hard-on, or that he "shaved and applied lotion," is this a Leroy-like imposture, or does the removal of certain actual capacities of the body allow access to the virtual?

Trace
Negative identity
Mask
Shell

As well as:

A flight from identity, not a means to explore alternate
identities
Neither absent nor present
A transpersona
Related to sexuality and sexual difference

Neither an ambiguous hermaphrodite nor a desexed eu-
nuch, but true neuter, having never been sexed, the negative
prosthesis tries to write itself. Unable to take on qualities
of its own, no longer attached to any object but retaining
the essence of an attachment, the only material the negative
prosthesis can find with which to describe itself is an al-
most parodic essence of quasi-feminine purity, or quietude,
or blankness. Like a tampon advertisement.

Could we consider this dude's fucking cologne? It has a distinctive quality that makes itself known. We say it resembles maleness because we associate its qualities with other qualities that as a whole refer back to some essential notion we have of maleness.

The cologne shows that he is unafraid to hide; it extends his presence. The cologne offers up its own distinct qualities while at the same time extending the qualitative reach of the male and his essence of maleness. Such a happy fusion between the protrusion of the male into our undifferentiated state of matter and the undisguisedness of his prosthesis!

Is the cologne a reference to the penis? The penis, also, we associate with this protusive quality. But is it out of insight or habit that we reduce the other qualities of maleness to the penis? What capacities must already be removed and virtualities ruled out before the penis appears self-identical as a thing? What is the ur-prosthesis allows the thing to be self-identical?

The mirror is a tampon. Neither the mirror or the tampon
is a thing; the function of each is to create the body as a
thing, a contained whole without spillage, etc. We admire
the self-negating feminine aspect of the tampon in the ads,
which sacrifices its qualitative presence (it can't be felt) to
bring about this synthetic wholeness. To absorb, contain,
and place limits on the body's dissipative structure.

The tampon contains these excessive processes, the excre-
tion into the world in the form of fluids that exceed the self.
The whole protudes, but is contained; this feminine excre-
tion into the world, on the other hand, exceeds the limits of
self-identity. The mirror-prosthesis, the tampon-prosthesis,
with its reflective, self-negating capacity, creates the female
body as a self-identical whole. But the tampon is an imper-
fect prosthesis.

The tampon advertisement is imperfect, so it is comic. Like something undigestible excreted by the body. The prosthesis is not perfectly adapted to the environment in which it evolved. The imagery does not resonate at the ideal frequency of innocuousness and blankness.

I imagine that Kotex creates a neural network to evolve the perfect tampon advertisement. To create an unbounded number of perfect tampon advertisements. Modelled after the evolutionary variety of the insect world, whose prosthetic adaption Bergson says is perfect. The perfection of the mechanical means the negation of the comic. White yoga pants. White blood cells. The aesthetic of the tampon commercial, functioning like an immune system.

It doesn't understand femaleness, but it has evolved in an environment that gives it some qualitative affinity with femaleness. In the female body, maybe, its programming recognizes another predator, like itself.

White yoga pants caked with acid that dissolve the penis.

In a New York Times thoughtpiece about a new Kotex advertising campaign, the author Elissa Stein is quoted as saying: "Fem-care advertising is so sterilized."

The Kotex advertisement asks: "Why are tampon ads so ridiculous?" And they are right. There IS something comic about the advertisements, the "white yoga pants," etc. As in Henri Bergson's sense: "Something mechanical encrusted on the living."

The model Lauren Wasser's leg is amputated following a case of toxic shock syndrome brought on by the synthetic fibers of a Kotex product.

And Henri Bergson writes: "THE BODY TAKING PRE-CEDENCE OF THE SOUL...THE MANNER SEEKING TO OUTDO THE MATTER, THE LETTER AIMING AT OUSTING THE SPIRIT."

Something mechanical encrusted on the living, and the me-chanical prosthesis encrusted (stained) with blood.

1. There exist the body and its parts, including mind, spirit, essence, etc.

2. The body is shaped by a negative presence, an outline that deforms and alters the body and which is not part of the body, although it coexists with the body in a state of attachment or prosthesis.

3. Wholeness, self-identity, etc., are affects of the body that have the potential to develop given certain configurations of the body and its relation to negativity.

4. The body is structured by sexual difference but is not complemented or completed by the other sex. Negativity is the closest thing the body has to an opposite.

5. By all accounts, the condition of existing in the feminine implies a heightened awareness of this structuring negativity. The affect of wholeness is always modelled after the penis. The female body's access to self-identity tends to be contingent.

6. Does the elimination of certain actual capacities of the body allow access to the virtual? It remains to be seen what structural affinity an injured body, one which has lost or has never developed self-identity, may have and continue to have with the feminine.

Bibliography

Bergson, Henri. "Laughter: An Essay on the Meaning of the Comic."
Coen, Jessica. "Someone Finally Says It: Tampon Ads Are Stupid."
Grosz, Elizabeth. *Time Travels: Feminism, Nature, Power.*
Newman, Andrew Adam. "Rebelling Against The Commonly Evasive Feminine Care Ad."
Phillips, Julie. *James Tiptree, Jr.: The Double Life of Alice B. Sheldon.*
Telfer, Tori. "Toxic Shock: Why This Woman Is Suing a Tampon Company After Losing Her Leg."

"You going to regret that"
"what are you doing?"

He's gone into a trance-state

physiognomes